LONDON'S EAST END

HISTORY TOUR

To Morgan Keane for all you have done for our two boys

First published 2017

Amberley Publishing
The Hill, Stroud,
Gloucestershire, GL5 4EP
www.amberley-books.com

Copyright © Michael Foley, 2017
Map contains Ordnance Survey data
© Crown copyright and database right
[2017]

The right of Michael Foley to be
identified as the Author of this work
has been asserted in accordance with
the Copyrights, Designs and Patents
Act 1988.

ISBN 978 1 4456 6882 6 (print)
ISBN 978 1 4456 6883 3 (ebook)

British Library Cataloguing in
Publication Data.
A catalogue record for this book is
available from the British Library.

Origination by Amberley Publishing.
Printed in Great Britain.

INTRODUCTION

The East End of London has always been seen as the poor relation of the city. From medieval times the area outside the city walls was the home of the less desirable elements of the capital's population. During the Napoleonic Wars it was even said that the population of the East End were to be more feared than a French invasion.

There have, however, always been more affluent pockets in the East End. When the area consisted of numerous small villages, a number of fine houses stood alongside the more humble dwellings. The majority of these disappeared during the spread of London in the nineteenth and twentieth centuries along with the villages, but some left their mark as local parks.

It was in the nineteenth century that the East End formed its long-lasting image of industry, the docks and mean slums. Industrial diseases and disasters blighted the lives of the poor forced to live in the area. During the Second World War it was the East End that bore the brunt of enemy bombing.

As can be seen from this series of images from around a century ago, much has changed. Some buildings remain and look remarkably similar, but the people who live in the East End today are more likely to have their roots in other parts of the world. The death of the docks has led to even more change, as much grander buildings have replaced the old dockers' homes and the warehouses that lined the river.

The East End is a fascinating area of numerous cultures living alongside each other with shops and markets sealing goods unimaginable a few years ago. Along with this are a few surprises among the closely packed buildings, with open spaces such as West Ham Park and arguably one of the best Olympic Parks in the world replacing what was once an industrial wasteland.

A tour through the East End is an experience not to be forgotten.

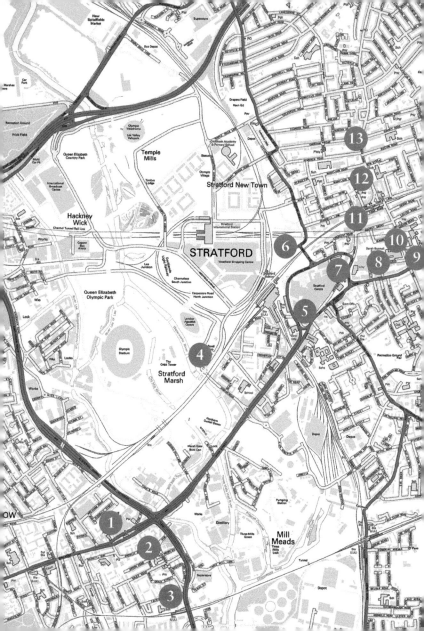

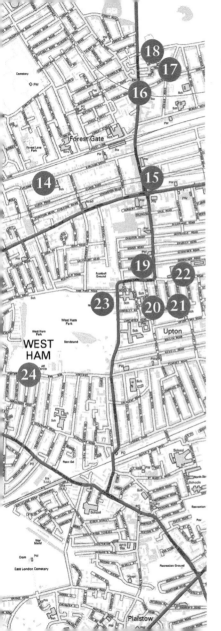

TOUR 1

Key

1. Bow Road
2. Bromley Church
3. Bromley by Bow Station
4. Temple Mills
5. Stratford Town Hall
6. High Street, E10
7. The Grove
8. Romford
9. West Ham Technical Institute
10. West Ham High School for Girls
11. Maryland Point
12. High Road E11
13. High Road E11
14. Earlham Grove
15. The Princess Alice
16. Forest Gate Hospital
17. Chestnut Avenue
18. Woodgrange Road
19. The Spotted Dog
20. St Antony's Church
21. Upton Park Road
22. The Ursuline Convent
23. West Ham Park
24. West Ham Park

1. BOW ROAD

Bow Road has a long connection with the railway. The old bridge across the road shown in the image was used by the Great Eastern Railway until 1949. The station once stood by the bridge. Bow Road Station, now on the District line, opened in 1902. There is also a Docklands Light railway station, Bow Church, a little further along the road.

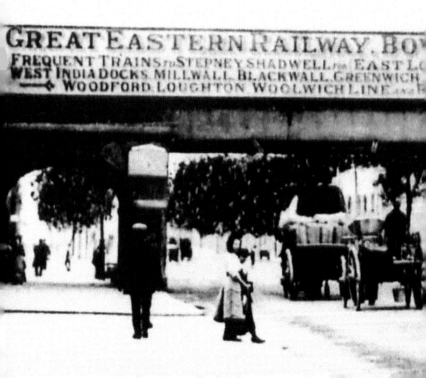

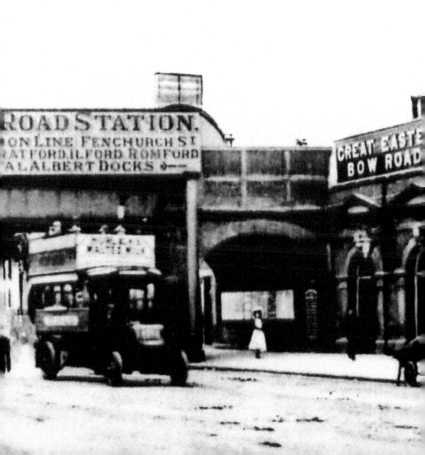

2. BROMLEY CHURCH

Bromley Church was originally part of St Leonard's Priory until the Dissolution of the Monasteries. It then became a parish church for the area until it was destroyed by bombing during the Second World War. The ruins of the church and its grounds were then lost to the new Blackwall Tunnel approach road. Only the gateway and part of the churchyard survive. It is a good example of the changes that have occurred in East London from conflict and development.

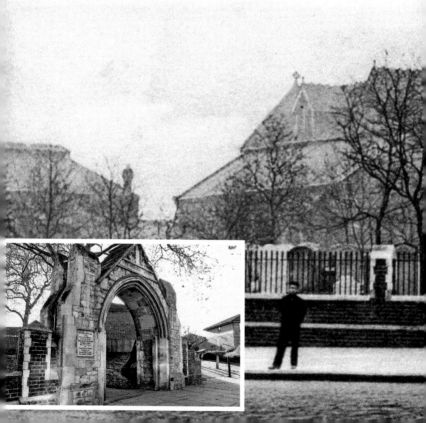

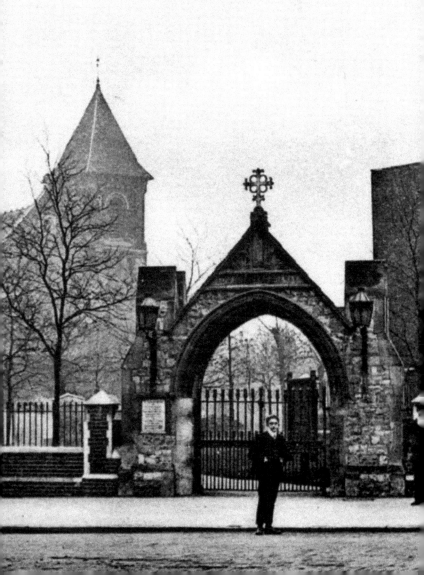

Bromley-by-Bow.

3. BROMLEY BY BOW STATION

Bromley by Bow Station is one of the earliest in the area, built in 1858 and called Bromley. The name was changed to Bromley by Bow in 1967 to avoid confusion with Bromley Station in Kent. The building to the left in the image is St Andrew's Hospital, which has now been replaced with a large housing estate.

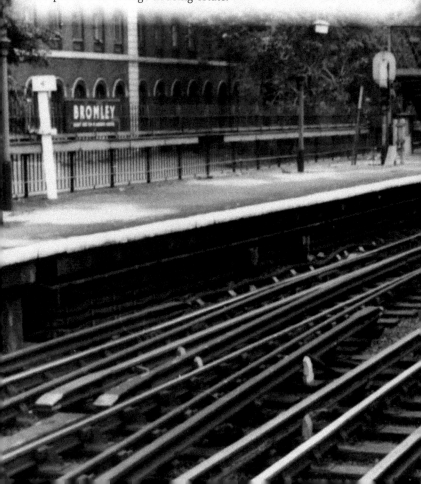

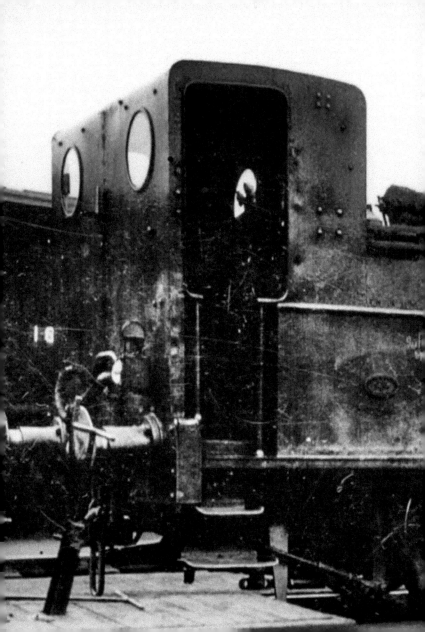

4. TEMPLE MILLS

Temple Mills began life as a Great Eastern Railway Works in 1850. It continued in use as a railway yard until most of it closed in 1991. The rest closed in 2007 and, along with nearby industrial land, it became the new Olympic Park for the 2012 Olympic Games. Many of the venues remain in use, including the main arena – now the home of West Ham United.

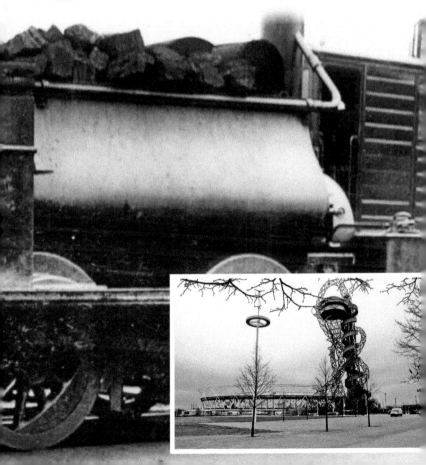

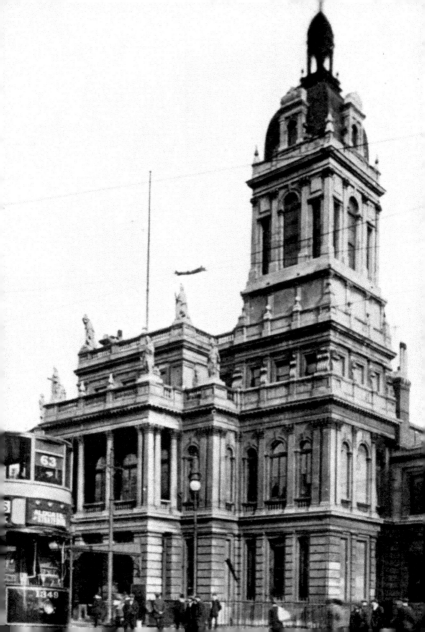

5. STRATFORD TOWN HALL

The town hall in Stratford has changed little since it was built in 1869. It was extended in 1884 and restored in the 1980s after a fire. The building itself may not have changed but the same cannot be said of the area around it, with the new Westfield Shopping Centre and the Olympic Park.

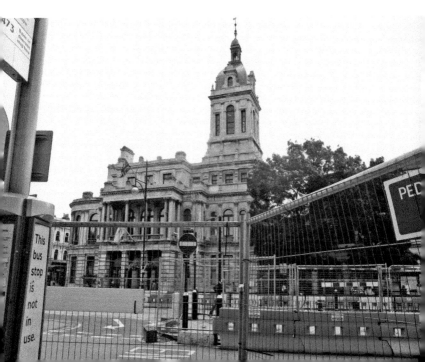

6. HIGH STREET, E10

High Road Leyton runs from Walthamstow in the north to Stratford. There are two railway stations in the road, Leyton Midland Road on the Gospel Oak line and Leyton on the Central line. Leyton Orient Football Ground also lies just off the main road. As with other main roads in the area, it has a variety of old and new buildings

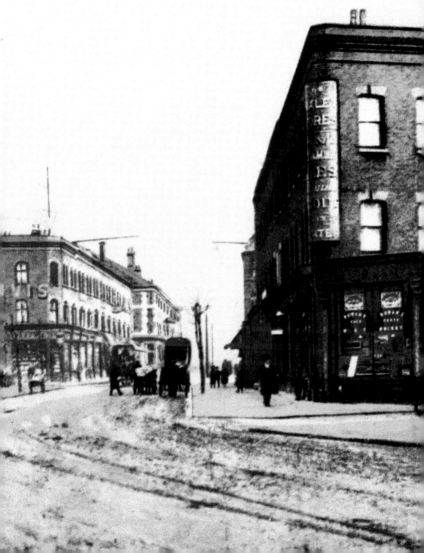

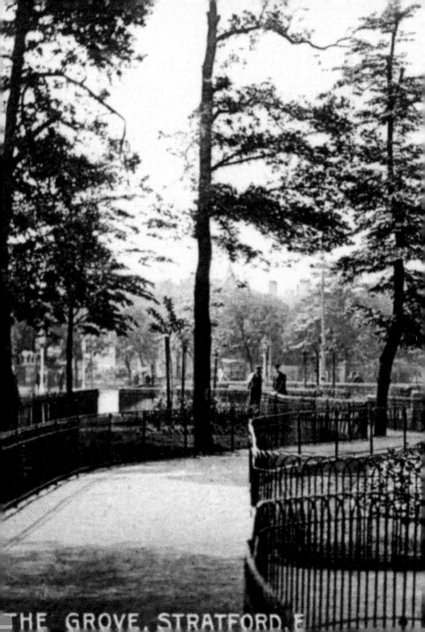

THE GROVE, STRATFORD, E

7. THE GROVE

The Grove has changed significantly since this old image was taken. The church in the background is almost completely obscured by trees, and the shops to the right are much more modern. A new library now stands opposite the site of the photograph and outside is a memorial to the poet Gerard Manley Hopkins.

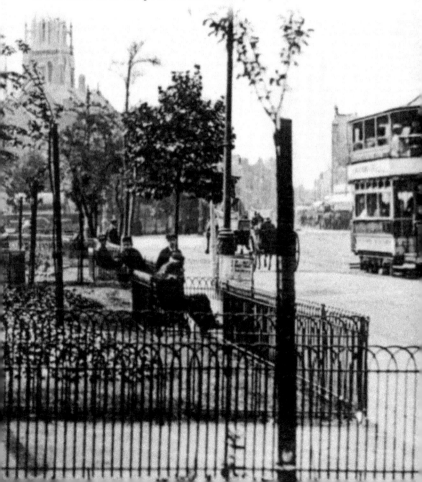

8. ROMFORD ROAD

The large houses lining Romford Road show that not all of East London was full of slums during the nineteenth century. As you move further out into what was once Essex, it becomes evident that not only the poor inhabited the area. That may not have been the case nearer the city but those living in these houses must have been better off than most East Londoners.

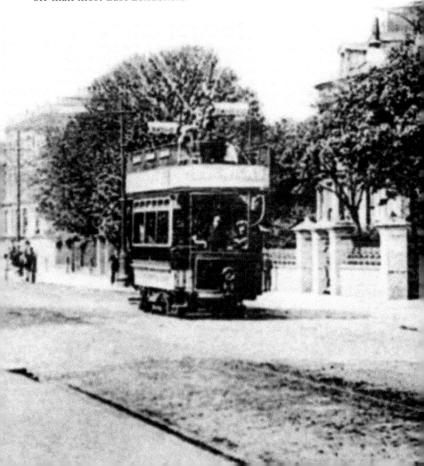

9. WEST HAM TECHNICAL INSTITUTE

The West Ham Technical Institute opened in 1892 and was called a people's university by John Passmore Edwards. Edwards was the businessman responsible for donating a number of public buildings to the people of the East End in the nineteenth century including libraries, schools and hospitals. Edwards' words became fact later when the building was part of the polytechnic and, later, the University of East London.

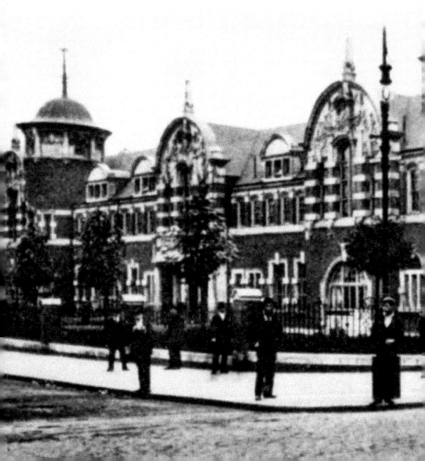

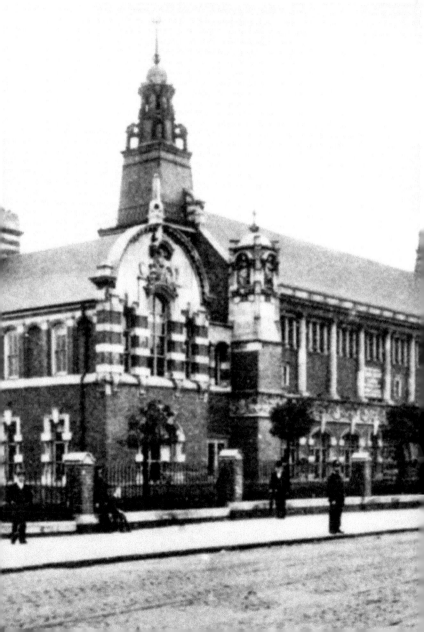

10. WEST HAM HIGH SCHOOL FOR GIRLS

The school opened in 1897 and was ahead of its time in having a sports centre for children with disabilities. In 1937 it became a secondary school for senior girls, and junior and infant boys. It became a mixed school in 1945, renamed Stratford Green School. In 1958 it became a girls' school again and is now part of the Sarah Bonnell Secondary School.

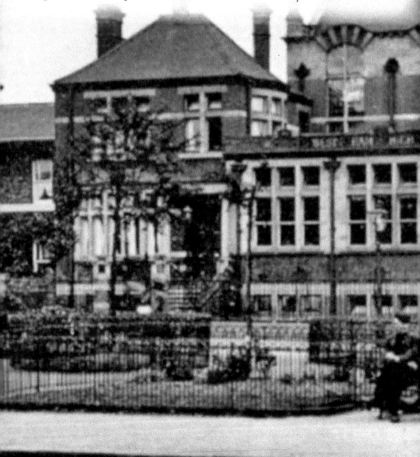

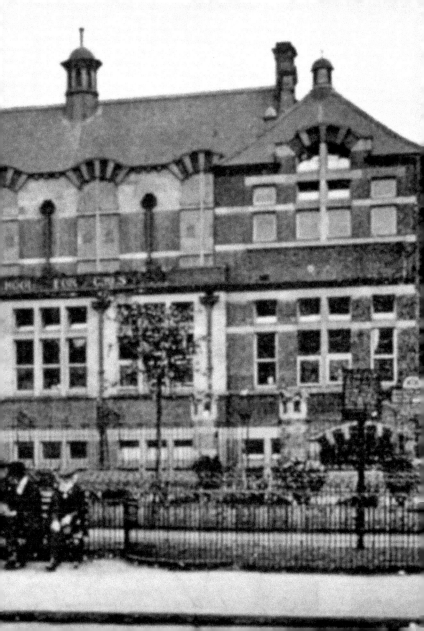

11. MARYLAND POINT

Maryland Point was named after a merchant bought land in the area after returning from Maryland in America in the seventeenth century. It has the distinction of being named after an area in America rather than vice versa. The Trinity Presbyterian Church at Maryland Point was built in 1870 and is a good example of the changes in East London. The church moved to new premises in Manor Park in the 1940s and the old church became a factory, much of which burnt down in the 1950s. The building that replaced it was built in the early twenty-first century.

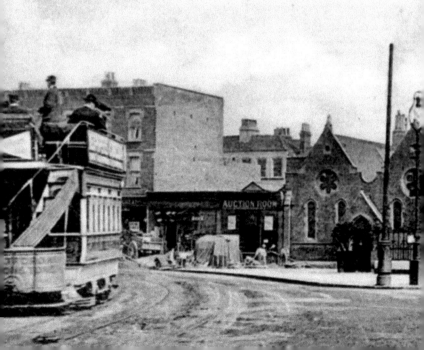

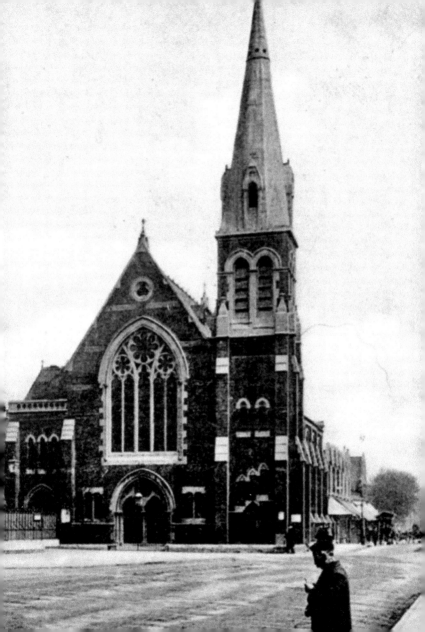

12. HIGH ROAD E11

Although Leytonstone High Road is similar to many other high streets in East London, there are parts of the road where the flats above the shops have become very rundown and are evidence of the pockets of poverty that still exist in East London. This varies, however, and there are often very poor buildings alongside some very nice, well-kept properties.

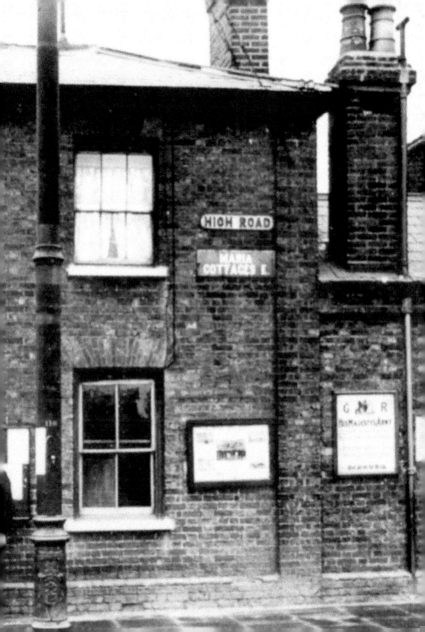

13. HIGH ROAD E11

Leytonstone High Road is a busy shopping centre, especially to the northern end where it leads to Whipps Cross. The items in the shops have changed greatly since the old image was taken, as have the customers. The area has become one of those populated by large number of immigrants as with other areas of East London, and the items for sale in the shops reflect the multicultural composition of the area.

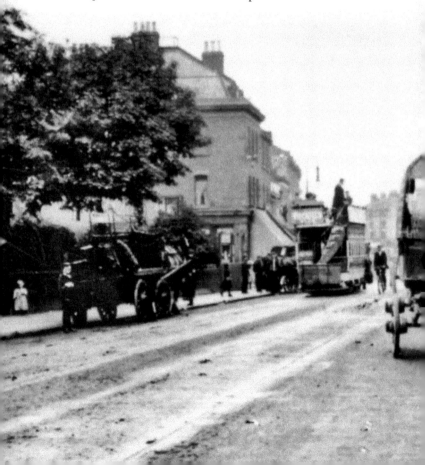

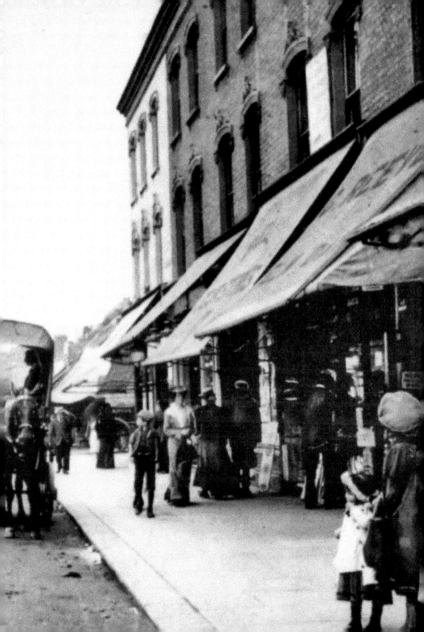

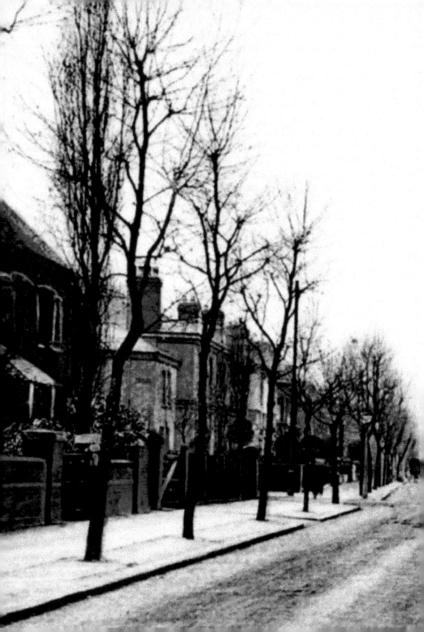

14. EARLHAM GROVE

Earlham Grove runs alongside the railway line between Forest Gate and Maryland Point. The houses in the road are a good example of how homes for the better-off workers were built within travelling distance of the city once the railway arrived in the area, a process that happened in many other parts of East London. During the First World War, a hostel for Belgian refugees fleeing the Germans was opened in the road.

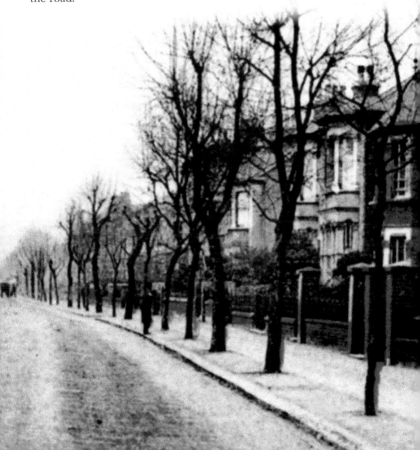

15. THE PRINCESS ALICE

The Princess Alice stood on the corner of Romford Road at its junction with Woodgrange Road. There seems to be some dispute over whether the pub was named after the daughter of Queen Victoria or the steamboat of the same name that sank in the Thames in 1878, with the loss of more than 600 lives. The latter would be more in keeping with East End tradition. The pub is no longer known by the name but the area is still remembered as the Princess Alice by older locals.

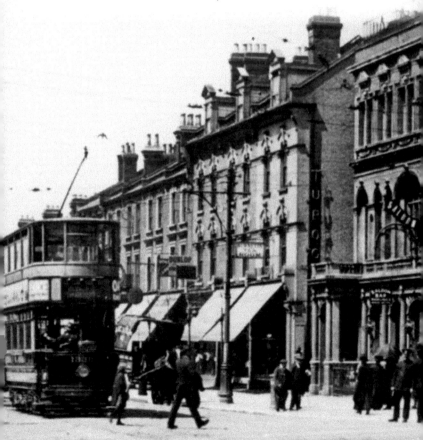

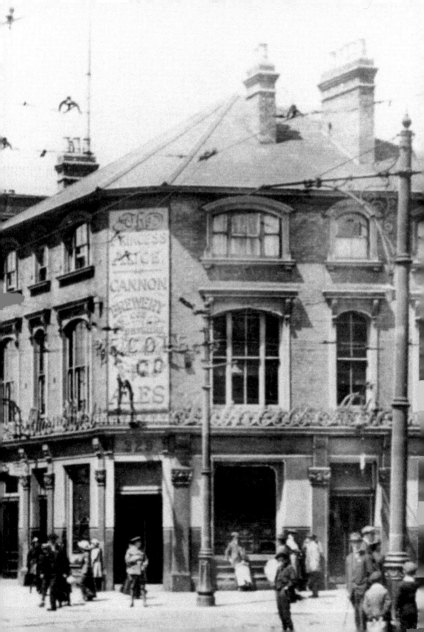

16. FOREST GATE HOSPITAL

The area has had a number of uses, originally being a school until 1913 when it opened as Forest Gate Home for the sick and mentally ill. It then became a hospital, and later Newham Maternity Hospital until it closed in 1985. The building was converted into flats but is now the site of Forest Gate Community School.

17. CHESTNUT AVENUE

There were evidently more trees in Chestnut Avenue in the past. In this old image, the trees on the right are actually in the road. These have obviously been removed as the road has been widened to accommodate the increase in road traffic and car ownership, but the houses still look very similar.

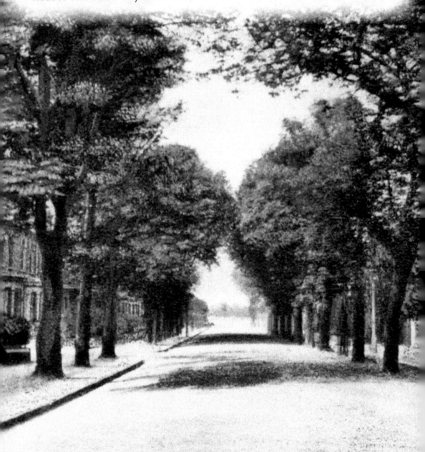

18. WOODGRANGE ROAD

Little of Woodgrange Road has changed, with the buildings still mainly shops with living accommodation above. Many of the original buildings have survived, although the nature of the shops has in most cases changed. It is another road with two railway stations on different lines; these are Forest Gate and Wanstead Park.

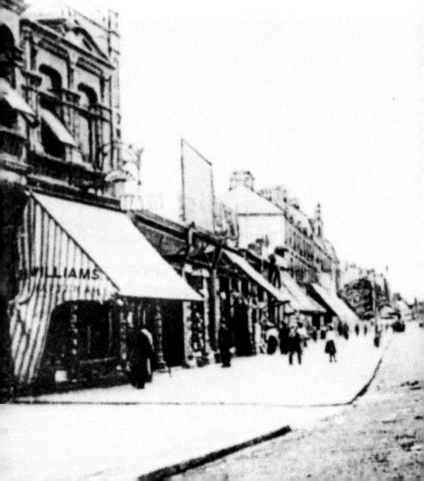

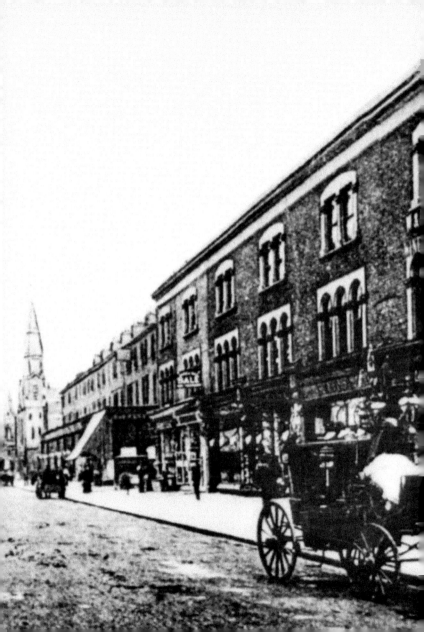

19. THE SPOTTED DOG

The Spotted Dog building originates from the sixteenth century when the area was still covered by forest. It became an inn in the nineteenth century called the Dog. It is thought that it was named after the royal hunting dogs. There have been additions to the building through its history and although it was a busy, well-used pub, it has now gone the way of so many others and has closed.

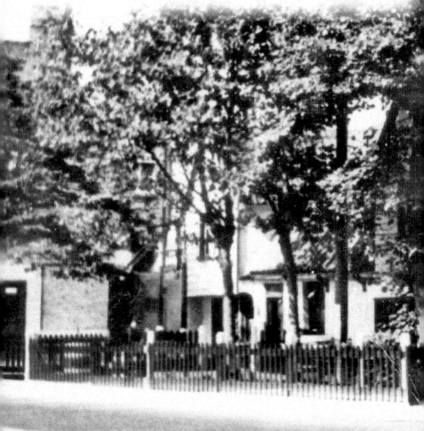

WH.12

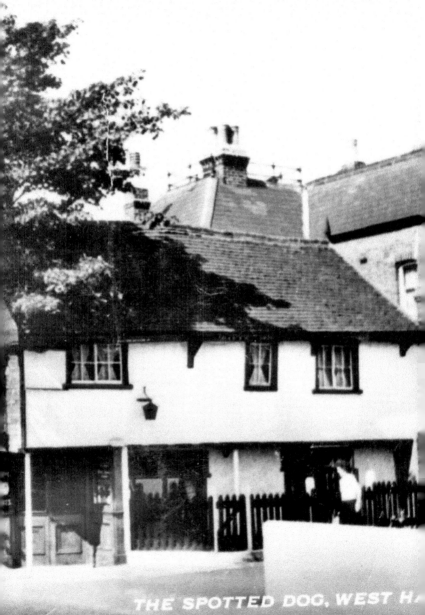

THE SPOTTED DOG, WEST HA

20. ST ANTONY'S CHURCH

St Antony's Church is a good example of the changing population in the area of Forest Gate. Built in the late nineteenth century for Irish Roman Catholics, it was once their main base in the area with around fifty priests, brothers and students based there, who would travel out to other parts of East London. The congregation attending the church are now more likely to come from much further afield than Ireland.

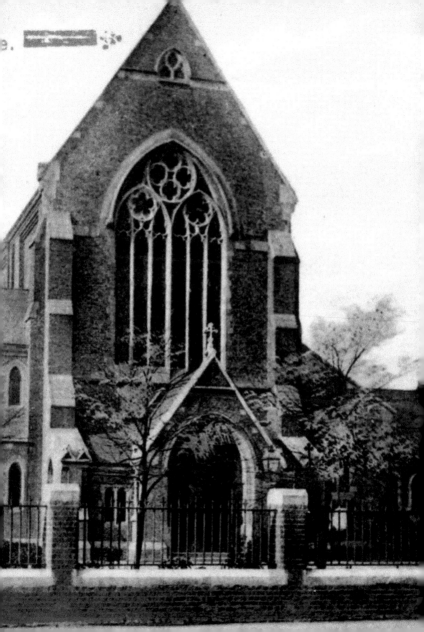

Upton Park Road

21. UPTON PARK ROAD

The image of Upton Park Road shows that not all of the houses built close to the railway system were for the wealthy. These homes were much smaller than those in places such as Romford Road, and were the type of home that a working-class person may have aspired to in the nineteenth century.

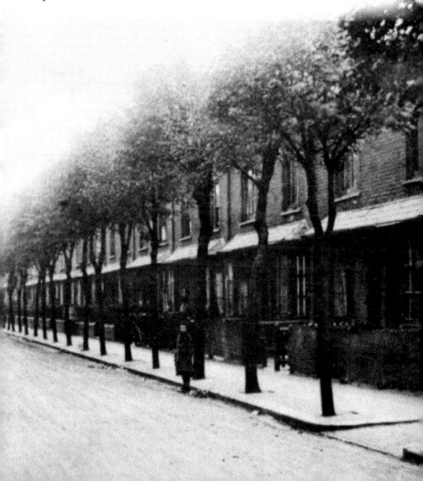

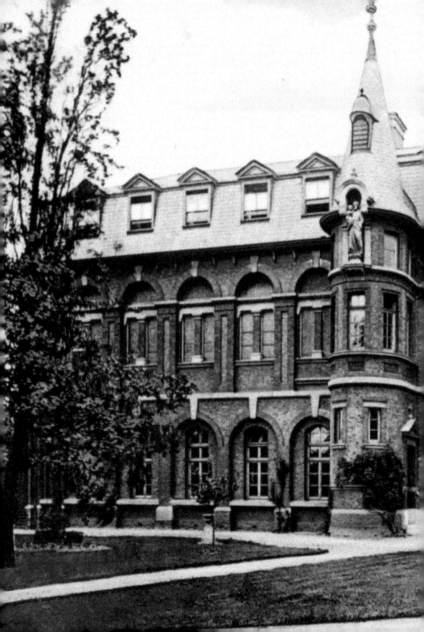

22. THE URSULINE CONVENT

The Ursuline Convent is another example of the strong Roman Catholic bonds with the local area in the past. Built in 1862, the sisters who ran the site took in boarding pupils from the mid-nineteenth century. It became a voluntary aided school and now caters for girls aged eleven to eighteen. Although still a Roman Catholic school, 90 per cent of its intake is from ethnic minorities, showing the change in the population since it was opened.

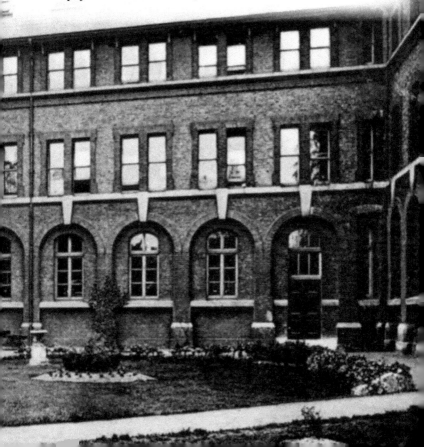

23. WEST HAM PARK

What is now West Ham Park was once part of the grounds of Upton House. When Dr John Fothergill owned the house, a botanical garden was begun, which included rare plants. The land was later owned by the Gurney family, and a monument to Samuel Gurney still stands in Stratford. Elizabeth Fry, the prison reformer, was a member of the family and was visited by many of the crowned heads of Europe at the house, then known as Ham House. A tutor to the family, Gustav Pagenstecher, was responsible for ensuring that when the land was sold for building in the nineteenth century, part of it was retained as a park.

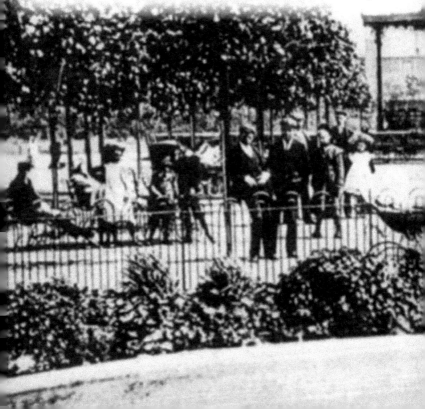

24. WEST HAM PARK

The park has been owned by the city of London since 1874 and is 27 acres in size. There is also a 7-acre ornamental garden. A book called *The Story of West Ham Park* was written by Gustav Pagenstecher, who, despite his long residence in England, became classed as an enemy alien during the First World War. The park also contains sporting facilities, a playground and a bandstand.

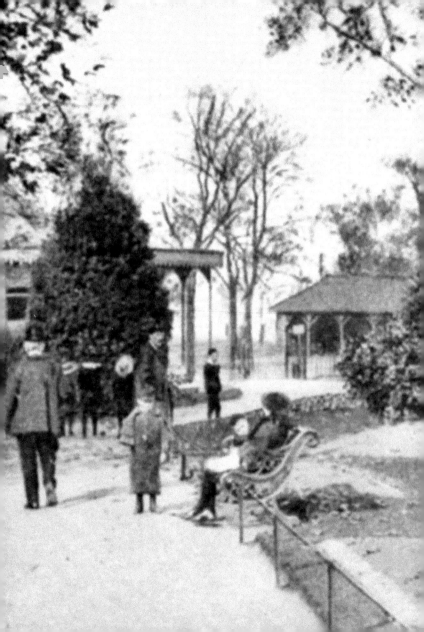

TOUR 2

Key

1. St Mary Magdalene Church
2. Central Park
3. East Ham Town Hall
4. The Denmark Arms
5. High Street North
6. Methodist Church, E12
7. Romford Road
8. Plashet Grove
9. Plashet Library
10. The Roundhouse
11. An East End Market
12. Boleyn Castle
13. Barking Road
14. Barking Road
15. The Greengate
16. Greengate Street
17. St Mary's Children's Hospital
18. Plaistow Station
19. Pelly Road
20. The Launching of the Albion
21. Star Lane School
22. Thames Ironworks

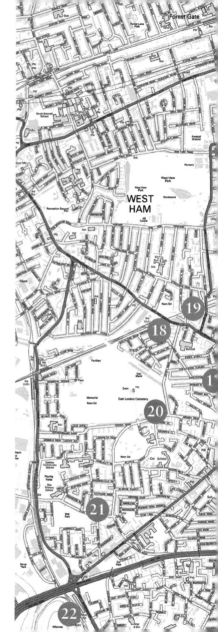

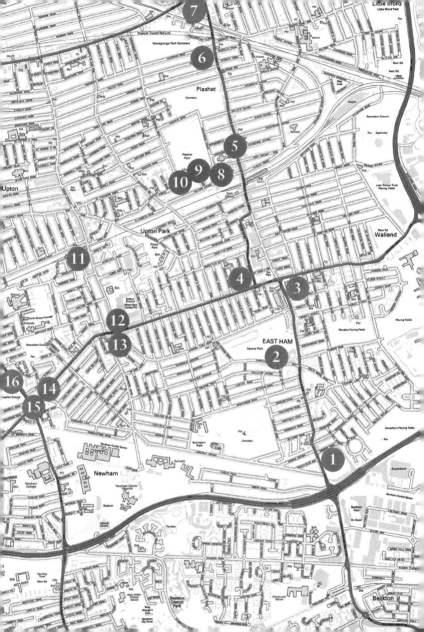

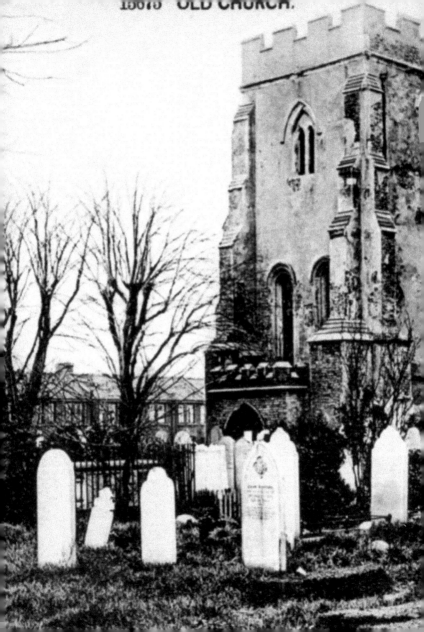

OLD CHURCH.

1. ST MARY MAGDALENE CHURCH

This old church in East Ham dates from Norman times and replaced an older wooden Saxon church. When it was built, East Ham was a tiny village and much of the present building has been renewed throughout its history. The building is still in use but the 10-acre churchyard is now a nature reserve with the trees almost obscuring the view of the church itself.

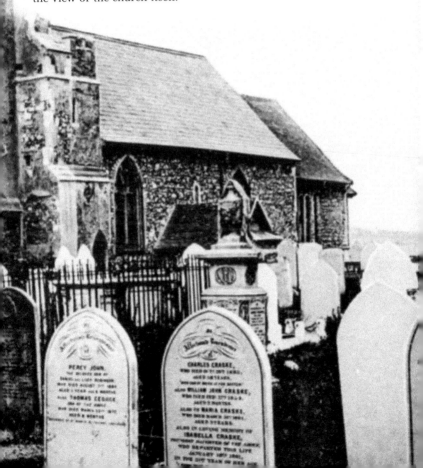

2. CENTRAL PARK

As with other parks in East London, Central Park was once part of the grounds of an old house. It was once part of the estate of East Ham Hall and the land was donated for us as a park in 1898. The boys in the image would have been old enough to fight in the First World War and their names might be remembered on the large war memorial that stands in the park.

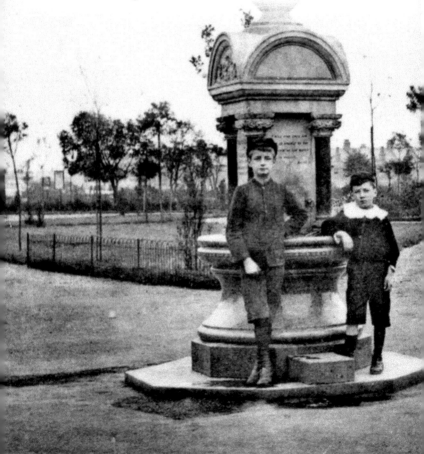

EAST HAM.

3. EAST HAM TOWN HALL

The town hall at East Ham just missed being classed as Victorian. It opened in 1903, making it Edwardian. It was opened by John Passmore Edwards and was the town hall for the borough of East Ham until this joined with West Ham in 1965, becoming the London borough of Newham. The building then became Newham Town Hall until more modern buildings were erected in E16.

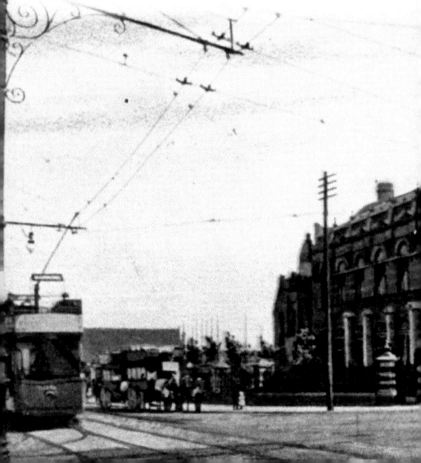

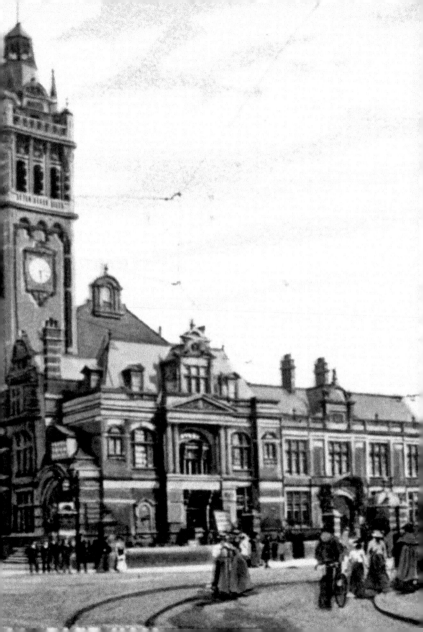

4. THE DENMARK ARMS

The Denmark Arms stands on the corner of Barking Road and High Street North. It is the kind of public house that graces the corners of many East London streets. Despite trying to attract customers with events such as live football, many of these old pubs now no longer manage to survive in their original use.

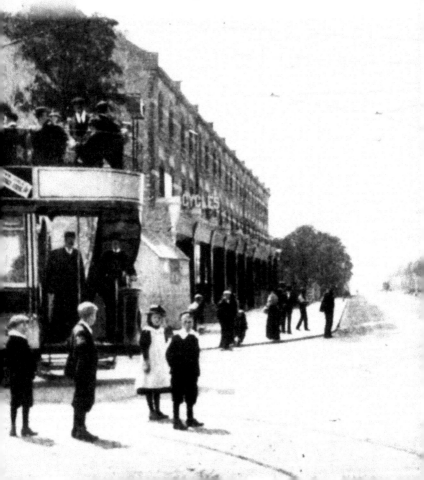

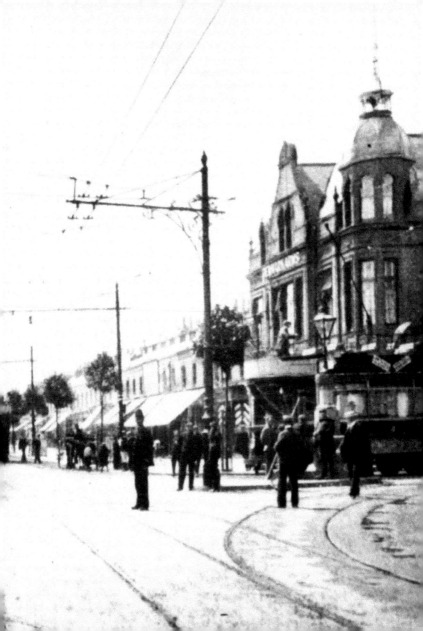

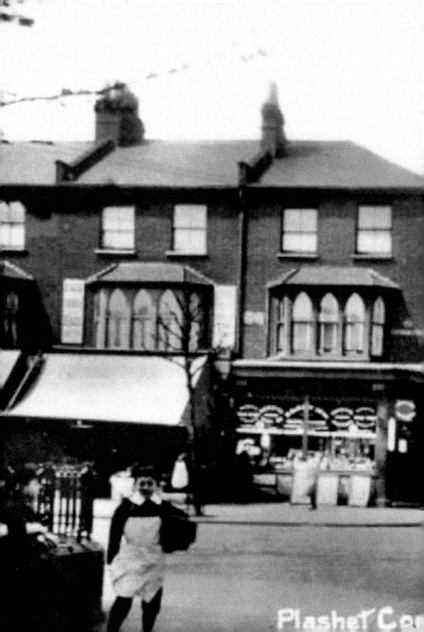

Plashet Co

5. HIGH STREET NORTH

The image shows the junction of High Street North and Plashet Grove, known as Plashet Corner. The old Victorian pub that stood on the right was the Burnell Arms but, like many other old East End pubs, it no longer exists and has been demolished in the past few years. The image also shows the trams that ran along Plashet Grove.

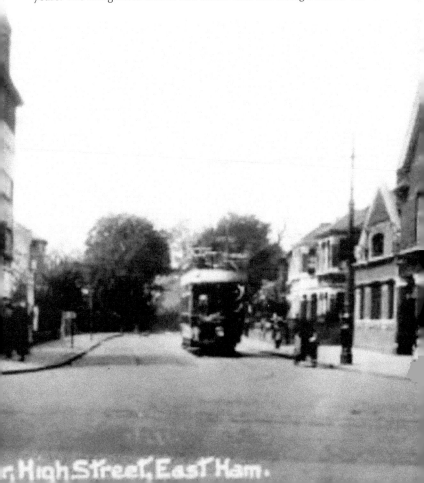

r. High Street, East Ham.

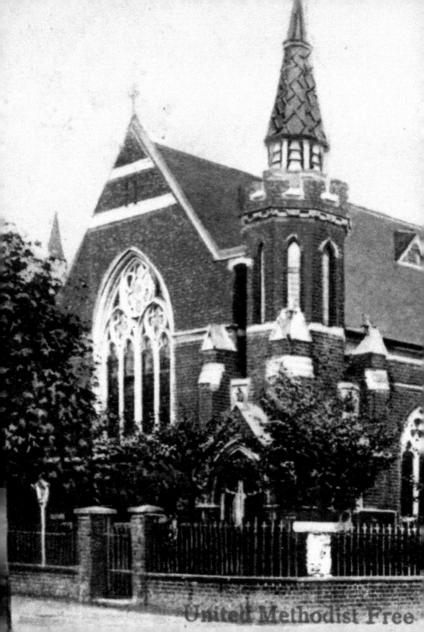

United Methodist Free

6. METHODIST CHURCH, E12

The size of the old church shows how strong the Methodist movement was in parts of East London. It stands in Manor Park, which the road leads to from East Ham. There has been a large extension added to the side since the old photograph was taken, which was no doubt used for many of the services that the Methodist faith provided for the poor above the religious aspect of their work.

...rch, Manor Park

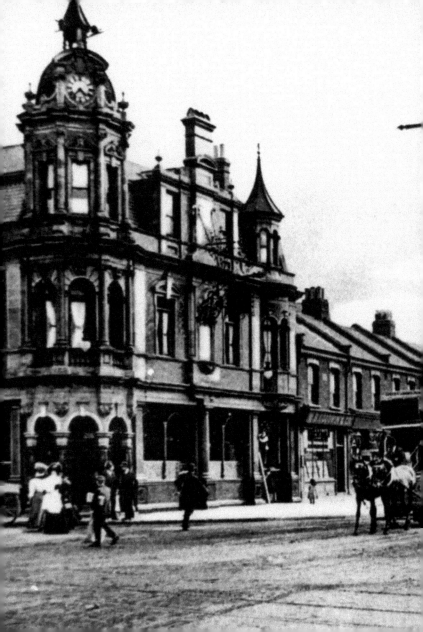

7. ROMFORD ROAD

The building on the corner of the road is a large Victorian public house. These were commonly found on the corners of main roads throughout East London. Unfortunately, few survive as their original purpose. In some cases, the buildings have survived almost intact for use as supermarkets or other retail outlets.

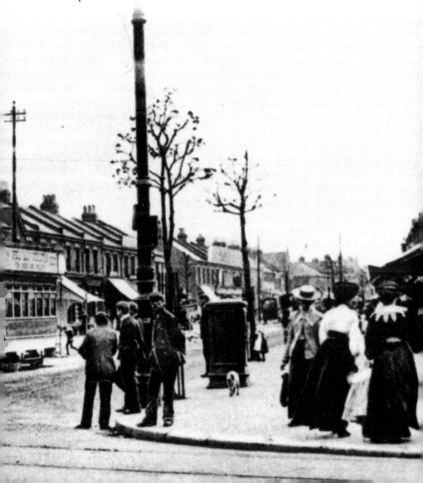

8. PLASHET GROVE

Plashet Grove is a busy road that runs from East Ham to Upton Park. The old image shows a tram that provided transport in the past. Plashet School now stands at the eastern end of the road and is based on both sides of the road, with a footbridge connecting the two sites over the busy route.

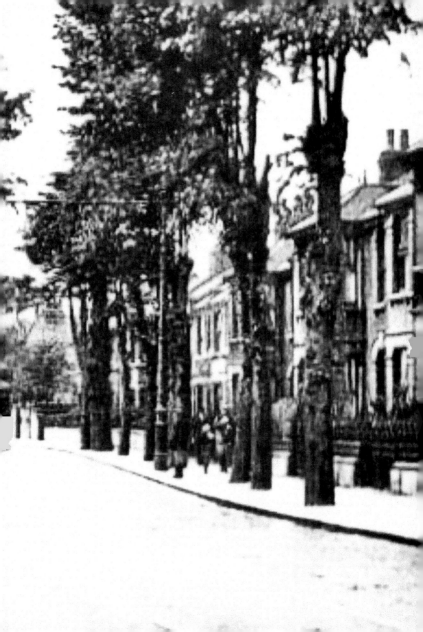

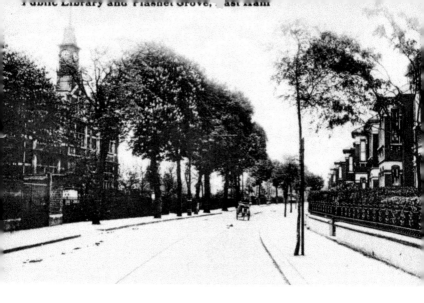

9. PLASHET LIBRARY

The library stands in Plashet Grove, in Plashet Park. As with many other libraries in the London Borough of Newham, it owes its origins to John Passmore Edwards (1823–1911). The former journalist, editor and Member of Parliament was responsible for the erection of more than seventy buildings such as art galleries, libraries, hospitals and schools. The library is a good example of the type of building that he was responsible for.

10. THE ROUNDHOUSE

The Roundhouse was an unusual octagonal cottage that once stood at the end of Shrewsbury Road. Although it does not look very large, it once had four families living in it. Overcrowding was very common in old East London. The building was demolished in 1894 when no doubt many of the present buildings were erected.

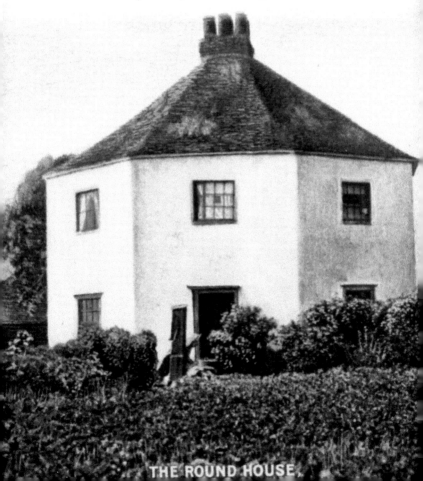

THE ROUND HOUSE.

11. AN EAST END MARKET

There is a very strong connection with markets in the East End, where many people once did their shopping. The market workers, known as costermongers, also have a long history in the area and there are connections with another East End tradition, the pearly kings and queens. Costermongers traditionally wore trousers decorated with pearl buttons. Henry Croft, a street sweeper, used these buttons to decorate his clothes and raise money for charity. The goods on offer and the customers in today's Green Street Market are very different but show the vibrant nature of East London's varied community.

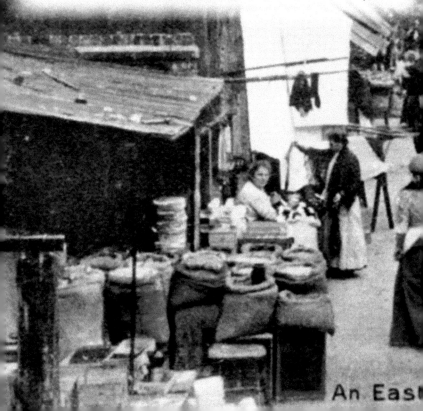

An East

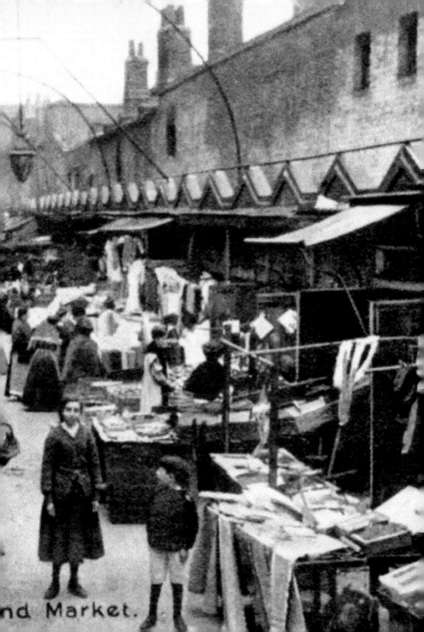

nd Market.

12. BOLEYN CASTLE

Upton Park House was known as Boleyn Castle because it was supposedly owned, or had been stayed in, by Anne Boleyn. The grounds of the house were rented by the local Roman Catholic church to a football club. The club became West Ham United and although it is known as Upton Park, their ground was actually the Boleyn Ground. The ground is now empty as they have moved to the Olympic Stadium in Stratford and it is being demolished to make way for housing.

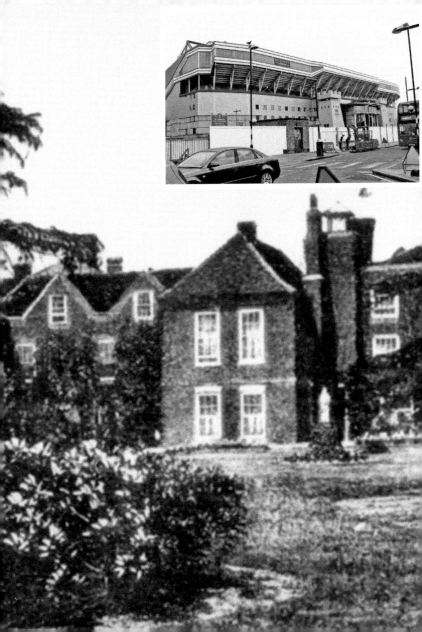

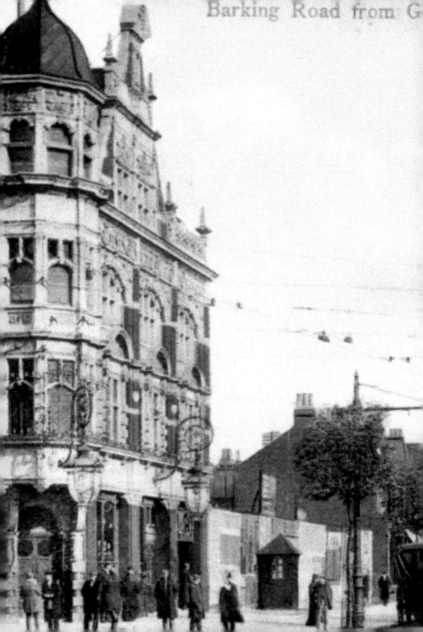

13. BARKING ROAD

The Boleyn public house stands on the corner of Green Street and Barking Road. It also takes its name from the old house that once stood nearby. The pub has always been very popular with West Ham United supporters and was always very busy on match days. As with other business in the local area, the loss of the club to Stratford has had an adverse effect on them, although the increased population from new housing on the old ground may go some way to improving this.

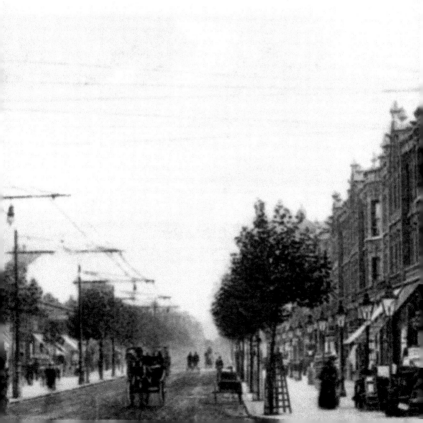

14. BARKING ROAD

The corner of almost every road junction with Barking Road seems to
have had a public house standing on it, and the junction at Plaistow
was no different. The pub in the old image was called the White
Horse but, as with other pubs in the area, it no longer exists. This does
not seem to have been a recent development, however.

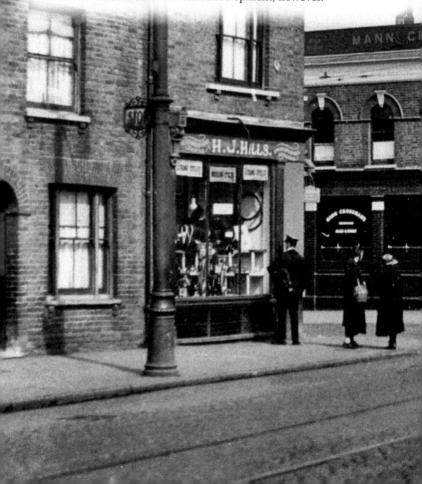

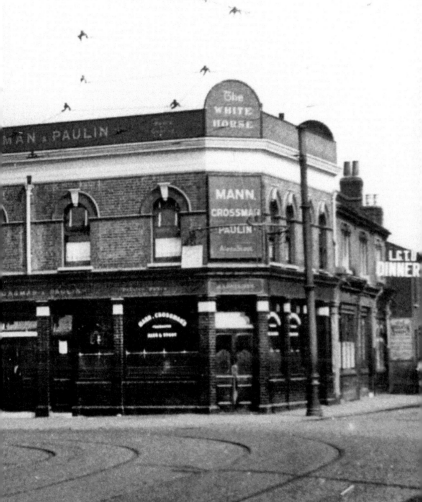

BARKING ROAD, CORNER, PLAISTOW.

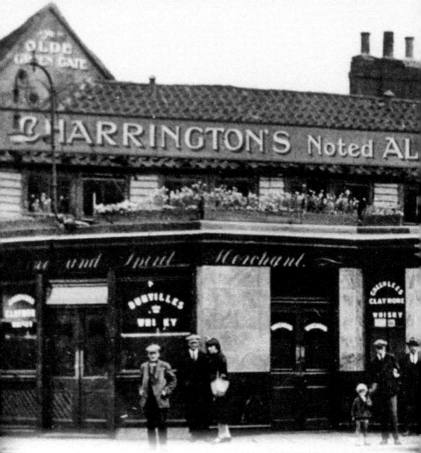

15. THE GREENGATE

The Greengate also stood on the corner of a junction with Barking Road but has had a more lasting impression on the area, with the road at its side being Greengate Street. The old image shows a single-story building so the pub has obviously been rebuilt sometime in the past. It now no longer serves the purpose it was built for, as with other local pubs.

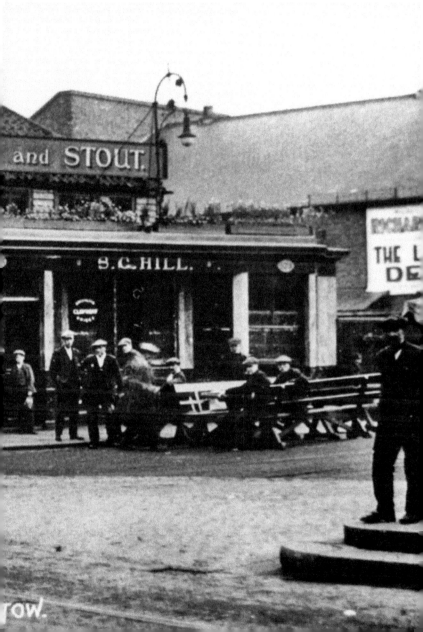

16. GREENGATE STREET

Greengate Street leads from Plaistow to Stratford and is a busy route through East London. The building shown in the old image was once a YMCA building. It later became part of the Polytechnic of East London, one of many annexes of the polytechnics that stood around East London. It later became the University of East London and has since moved to a large campus in Docklands. The building has now been converted into flats but the exterior has hardly changed.

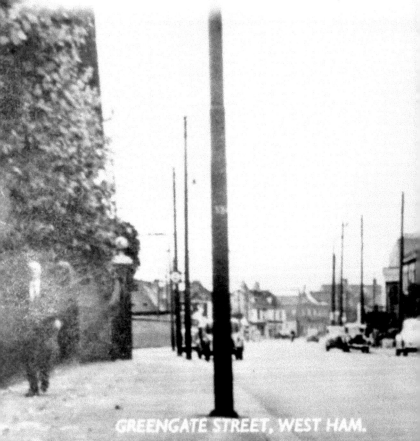

GREENGATE STREET, WEST HAM.

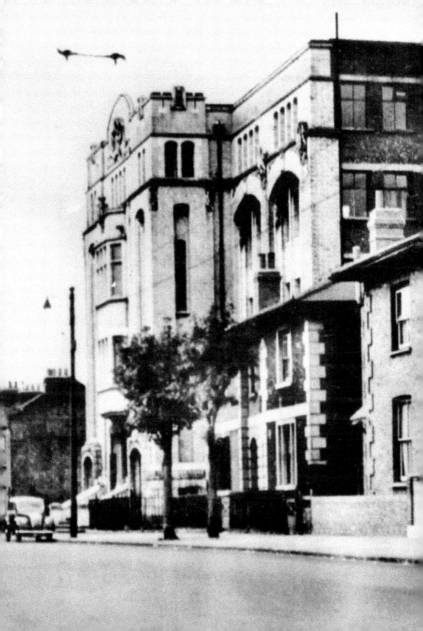

17. ST MARY'S CHILDREN'S HOSPITAL

A big difference between healthcare in the past and the present is the number of small hospitals that existed in East London at the turn of the century. The more modern method is to concentrate healthcare in large hospitals that serve a greater area. The St Mary's Children's Hospital stood in Howard Road. Although the hospital is no longer there, a medical connection still exists with an ambulance station.

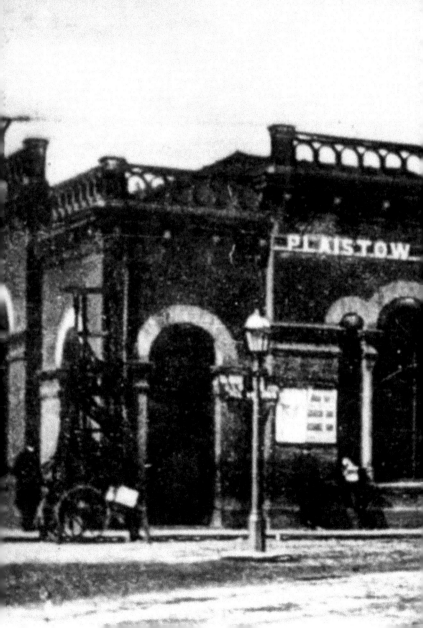

18. PLAISTOW STATION

Plaistow Station is one of the older stations in the area, built in 1858 by the London, Tilbury & Southend Railway. This was in the days when numerous railway companies fought for the best routes. The station has changed little since it opened. In 1902 the District line began to run through the station and there were also large sidings to the north side of the line. These are now gone and are covered by a large car dealership.

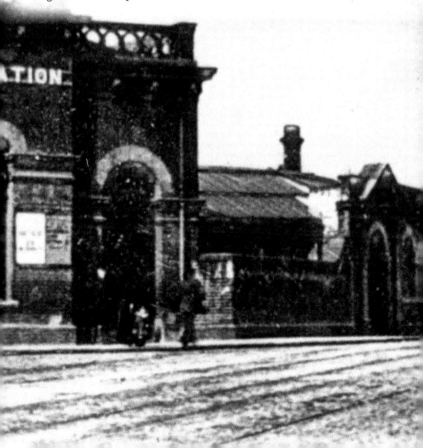

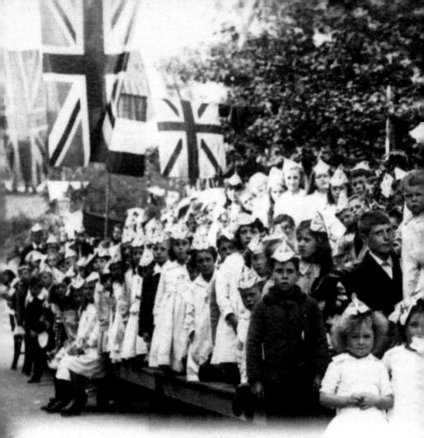

19. PELLY ROAD

The old image of Pelly Road shows a victory party held after the end of the First World War in 1919. The road was a very different place to what it is today. In the past it consisted of mainly small terraced houses. Today, there are few of these remaining and have been replaced by modern houses and flats. No doubt some of this would be as a result of enemy action in the Second World War when many East London houses were destroyed by heavy enemy bombing.

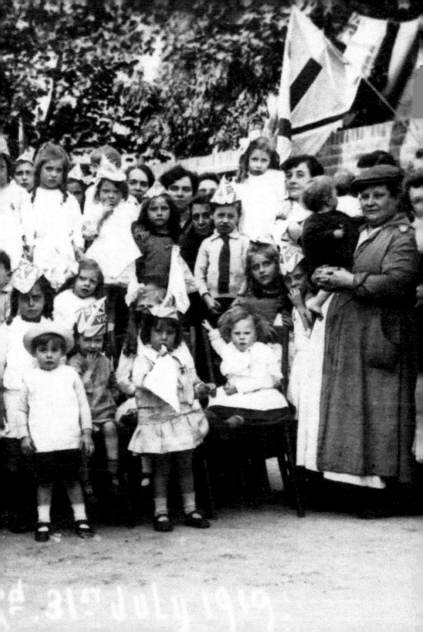

d. 31st July 1919.

20. THE LAUNCHING OF THE ALBION

One of the worst disasters to occur in the East End took place at the launch of the Albion at Thames Ironworks in June 1898. There was an estimated crowd of 30,000 watching the launch. The local schools had been given the day off, which showed the importance of the industry to the local area. The launch was carried out by the Duchess of York and the royal party left unaware that the wash from the ship, which was launched sideways into the creek, had caused a wave that washed hundreds of spectators into the river. Thirty-eight drowned, including women and children. A number are buried in a large grave at the East London Cemetery, paid for by a public subscription.

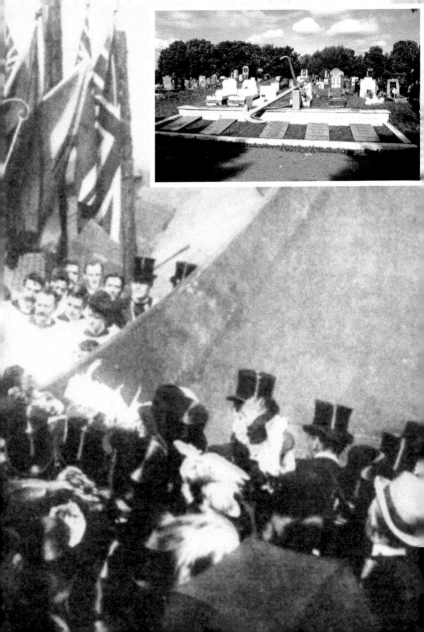

21. STAR LANE SCHOOL

The majority of children in East London in the twentieth century were taught in schools built in the nineteenth century. The old Victorian three-story buildings were a common sight, easily visible over the rows of streets with two-story houses. The majority of the buildings are still in use today, with adaptions, but they no longer stand out, as the buildings around them are often now much taller than the schools.

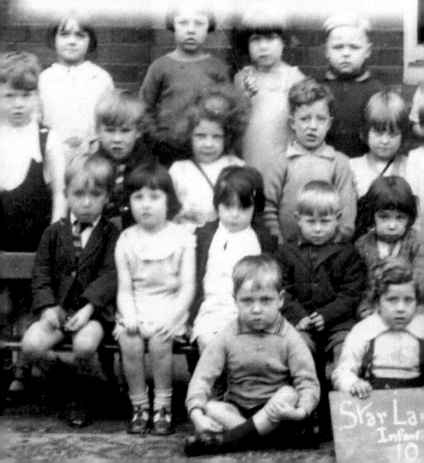

22. THAMES IRONWORKS

The ironworks was one of the last large shipbuilding companies to survive on the Thames and was situated on Bow Creek by Canning Town Station. They built a number of large ironclad battleships, many of which were used during the First World War. They are perhaps best remembered today for their works football team, better known as West Ham United. The crossed hammers on their badge and the chant of 'come on you irons' hark back to their shipbuilding past. The yard's memory is kept alive with a memorial inside Canning Town Station.

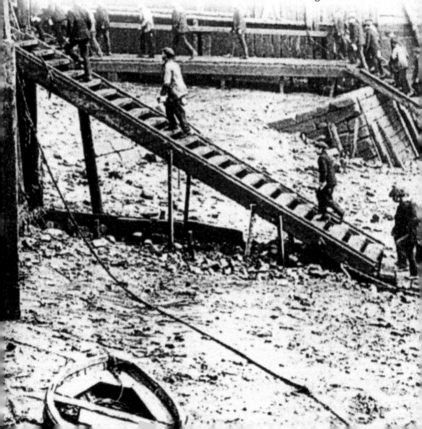

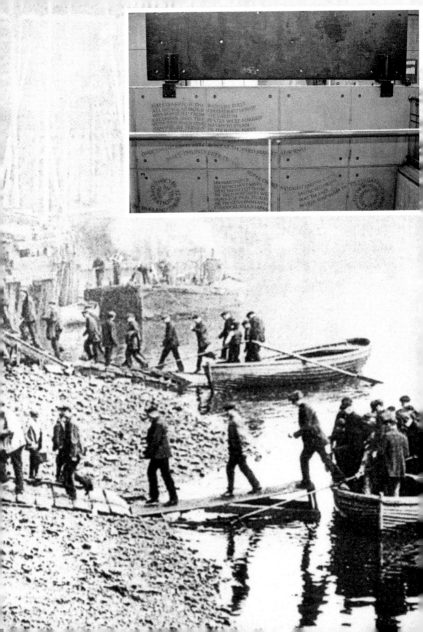

AUTHOR BIOGRAPHY

I was born and have lived in the East End of London all my life, and I have seen many of the changes that I have written about occurring before my eyes. I completed my degree at the University of East London in the centre of Stratford. I then went on to spend my teaching career in the East End, seeing the population change from white working class to a much more multicultural mix.

I started writing after giving up teaching to become a full-time carer for my twin grandsons who were severely disabled. Since then I have written twenty-six non-fiction books. Many of these have been local titles but I have also written more general history books, mainly military titles. I have also published three novels as e-books.

I have also written numerous articles for various magazines, as well as short stories. I also wrote a column in a local newspaper about West Ham United during the 2015/16 season.

www.michael-foley-history-writer.co.uk